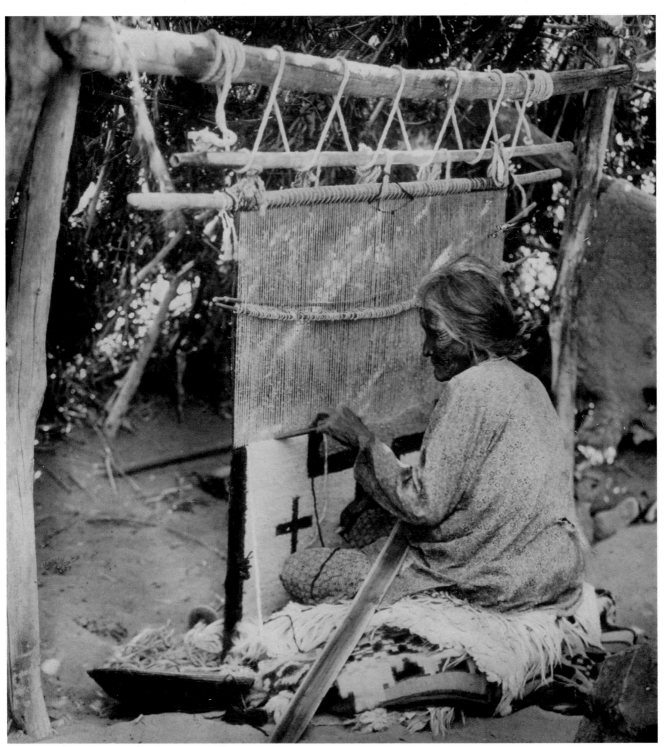

A Navajo weaver seated at her upright loom.

Those who have participated in the publication of this handbook know how much of its final form is due to the extraordinary knowledge and energy of my friend and colleague, Joe Ben Wheat. His long-standing interest in Southwestern textile collections led him to add to his already heavy schedule the responsibility for writing the text for this book. He also selected the textiles to be photographed. Without his enthusiastic cooperation and unfailing courtesy, this project would not have been possible. We are all in his debt.

Robert H. Dyson, Jr.
Director
The University Museum

Cover: See page 27, plate 6.

The Gift of Spiderwoman

SOUTHWESTERN TEXTILES
The Navajo Tradition

by
Joe Ben Wheat

with photographs by
Eric Mitchell

Navajo country, rider on horseback.

ACKNOWLEDGMENTS

The preparation of this publication, along with the one-day symposium and exhibition "Southwestern Textiles: The Navajo Tradition," was made possible through the combined efforts of many people.

Without the encouragement and support of Robert H. Dyson, Jr., Director of The University Museum, and Gregory L. Possehl, Associate Director, the project would never have been initiated. William R. Coe, Curator of the American Section, provided access to the collection.

Mary Elizabeth Ruwell, Archivist, along with her knowledgeable staff members Caroline Dosker and Eleanor King, greatly facilitated research on the history of the collection. Mary Anne Kenworthy, Photographic Archivist, offered her assistance in selecting the ethnographic photographs that appear in this handbook.

Eric Mitchell was responsible for the textile photography, and Gei Zantzinger, a member of the Museum's Board of Overseers, served as photographic consultant.

Dr. David Wenger of The University of Colorado Health Science Center supplied the results of his dye analyses of red yarn samples taken from several textiles shown here.

A special thanks goes to Fred Boschan, founder and past president of the Textile Arts Society of Philadelphia. Along with other contributions, he willingly tackled the difficult task of identifying textiles in the collection.

The production of this handbook was coordinated by Barbara Murray of the Museum's Publications Division who shepherded it through each stage. Jennifer Quick edited the manuscripts, and Martha Phillips designed the publication. Gei Zantzinger's contribution enabled us to present all of the textiles in full color.

Elin Danien, Public Programs Coordinator, conceived of the symposium and carried it through to its successful completion. Capacity attendance was guaranteed through the advance publicity arranged by Phoebe Resnick and her able Public Information Office staff.

The Museum expresses its sincere gratitude to all those who offered their generous assistance.

Pamela Hearne
Keeper of the American
Collections

The Gift of Spiderwoman Legend

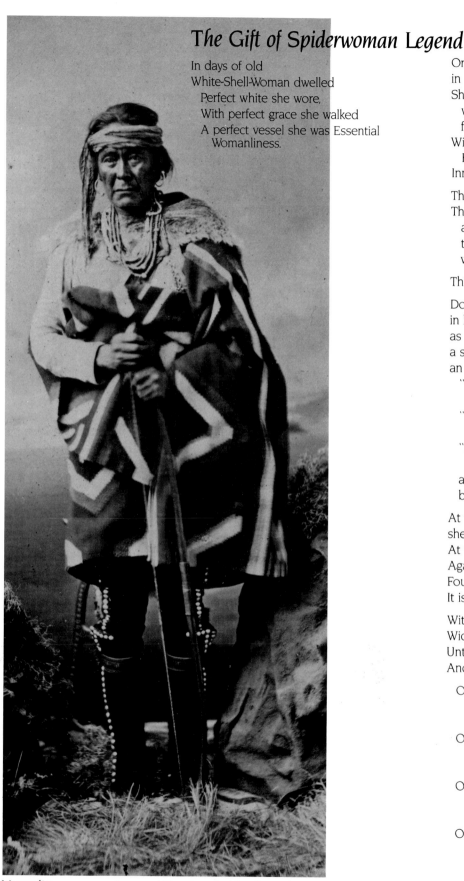

In days of old
White-Shell-Woman dwelled
Perfect white she wore,
With perfect grace she walked
A perfect vessel she was Essential
Womanliness.

One morning walking about
in the white of dawn
She came upon a stream of smoke
wafting skyward
from the ground.
With wonderment she approached the
Earth-hole.
Innocently peered within.

There in dusky depths
There in musty dimness
an Old-One worked
tying a thread
weaving a web.

This was the home of Spiderwoman.

Down
in her earth-lined chamber
as Spiderwoman wove
a shadow blocked her light above
an astonished face looked in.
"Come down into my home,"
Spiderwoman directed.
"It is too small,"
White-Shell-Woman objected.
"It is big enough,"
Dark-Black-Weaver insisted
and so saying
began to blow.

At the hole
she blew—
At the entrance overhead.
Again and again she blew,
Four times in all
It is said.

With each puff the portal opened
Widened, grew and swelled
Until a passageway stood large enough
And four ladders lined the walls.

On the East was a ladder white
with rungs of shell—
the color of dawn.
On the South was a ladder blue
with rungs of turquoise—
the color of sky at noon.
On the West was a ladder red
with rungs of abalone—
the color of the setting sun.
On the North was a ladder black.
Its rungs were jet.
—for such is the color of night.

Manuelito was one of several Navajo tribal leaders who signed a treaty in 1868 allowing the Navajo to return to their homeland after internment at Bosque Redondo.

Descending
into the damp dimness
the woman looked around her.
Woven forms
surrounded her.
Beautiful to behold!

"Yes, I made them all.
That's what I do.
 And WHAT do YOU do?"
Inquired the Dark-Black-Weaver.

White-Shell-Woman considered
 the question with care:

She thought about the way she had lived
 for so long.
She thought about the corn she had ground
 for so long.
She thought about the empty void she had felt
 for so long.

"It's not good doing nothing,"
 White-Shell-Woman concluded
 sitting down wistfully.
"It's not good doing nothing,"
 Spiderwoman repeated
 and retreated to her web.

White-Shell-Woman watched
 the quiet twining
 fingers working
 designs unfolding
She sensed here—Vital Being
She sensed here—Basic Meaning.

Something
for the hand to do
for the eye to see
for the mind to hold.

"Maybe,"
she ventured
"If I watch you weave
 see you do it
 twine the thread.
"Maybe
If I watch you now
 join the color
 shape the whole.
"Perhaps with Time . . .
"Perhaps with Patience . . .
 I, too, could learn Your Way."

There came no answer
No response
The hands continued weaving.
Yet rhythm and sound were enough
to impart a hopeful feeling.
 This Way is not for everyone, yet
 you show Courage by coming.
 This Way is not an easy one, and yet
 there's patience in your Being.
 This Way is not for all
 yet I sense
 Insight and Knowing.

In this way
Acceptance came
 to stay
 to watch
 to learn.
From Master-Weaver herself it came
From Seer-Beyond-The-Time.

Four days White-Shell-Woman stayed and
 watched
 with patience and
 understanding.

And in this time that she stayed
And in this way that she watched
 She was given the Knowledge of Weaving.

© Noël Bennett 1975

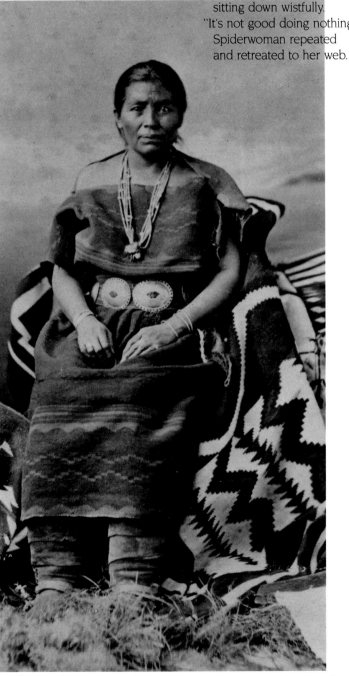

For her studio portrait taken in the 1870s, Juanita Pal ti-to, wife of Navajo tribal leader
Manuelito, is wearing a traditional two-piece dress.

7

INTRODUCTION

by
Pamela Hearne

In preparing this publication, the intention was that it serve not only as an accompaniment to the symposium "Southwestern Textiles: The Navajo Tradition" held at The University Museum, University of Pennsylvania, but that it define the scope of the Museum's holdings of Southwestern textiles, which remain relatively unknown to the public. Information regarding the size, range, and historical background of the collection should prove to be useful to scholars, weavers, and collectors.

This collection comprises textiles woven by Navajo Indians, Pueblo Indians from both New Mexico and northeastern Arizona, and Spanish colonists who settled in the Rio Grande Valley of New Mexico. Also included are Saltillo sarapes produced in the general region of the town of Saltillo in northern Mexico. Any study of the Navajo weaving tradition must include textiles woven by the cohabitants of the greater Southwest. Navajo weaving did not develop in a vacuum. Always receptive to foreign design systems and styles of clothing, Navajo weavers incorporated elements of other weaving traditions into their own.

Since the early 1900s, the collection of approximately two hundred Southwestern textiles has grown through a process of gradual accumulation. A large number were acquired on Museum-sponsored expeditions at the turn of the century or were included in large collections of Indian artifacts, amassed by private collectors, which became part of the Museum's vast holdings. Other textiles have been acquired through an exchange with the Denver Art Museum in the 1950s and as part of a collection of American Indian material made by Amos H. Gottschall between 1871–1905 that was given to the Museum on permanent loan by the Academy of Natural Sciences of Philadelphia.

Many of the textiles are not well documented. Often a donor can provide only vague recollections of a great uncle who traveled in the Southwest in the early 1900s. For those textiles collected on Museum expeditions or by early collectors, however, some documentation is provided. Information is often limited to date of collection and provenience, although some collectors kept records noting how a textile was acquired and from whom.

Documentation of these textiles greatly increases their value for research purposes. For those studying the stylistic development of Navajo weaving within historical contexts, well-documented textiles serve as indicators, enabling researchers to determine when changes occurred. Working within a framework of a limited number of well-documented pieces, it is possible to trace the evolution of style over time.

The University Museum is fortunate to have a considerable number of Classic Period and late Classic Period textiles, dating from the early 1800s to ca.

1875. During this time, Navajo women were weaving articles of clothing for their family members and blankets for trade with other Indian tribes. Included in the collection are a number of Navajo women's two-piece dresses, Chief blankets representing all three phases of development, and women's and children's shoulder blankets. Possibly the finest pieces in the collection are a Classic Period sarape, the Navajo version of a Spanish sarape, and a poncho sarape.

One of the most important textiles in the collection is a First Phase Chief blanket which was collected by George Byron Gordon, Director of The University Museum between 1910–1917. Well known for his discriminating taste, Gordon acquired some of the Museum's finest examples of Navajo weaving while traveling through the Southwest in 1908.

One late Classic Period child's blanket is part of the large collection made by Charles H. Stephens in the late 1800s. Stephens, a commercial artist, began to collect Indian artifacts in 1876 when he purchased objects from Seminole Indians in Florida. The bulk of Stephens' collection was acquired through exchanges with other collectors and purchases from dealers. Through his accurate records, Stephens noted the provenience and history of each object. This enables us to know that he acquired several pieces that had belonged to explorers Lewis and Clark, and collector George Catlin. The previous owner of the child's blanket was Lt. George M. Wheeler, a topographical engineer who in 1871 was placed in charge of a surveying project in the western United States.[1]

Although the Museum's collection of Pueblo Indian textiles is not extensive, there are over twenty well-documented Hopi Indian pieces collected by Stewart Culin on the John Wanamaker Expeditions of 1900–1903. One of the Museum's founders, Culin became its Director in 1896. He traveled throughout the West on three consecutive summer expeditions with George A. Dorsey of the Field Museum of Natural History (then called the Field Columbian Museum), each man collecting for his respective institution.

Among the articles of Hopi traditional clothing in the collection are shoulder blankets, mantas/dresses, kilts, belts and sashes. One white cotton wedding manta, complete with reed container used to hold part of the bride's costume, was acquired by Culin from the Reverend H. R. Voth. A Mennonite immigrant from Russia, Voth had established a mission among the Hopi Indians in 1893. He studied Hopi religion and language while performing his missionary duties for nine years at Oraibi, at that time the largest Hopi community.[2] The ethnographic collections which Voth put together for a number of museums, including The University Museum, are well known for their accurate documentation.

Several articles of traditional Zuni clothing were given to the Museum in 1901 by Franklin Hamilton Cushing, the first person to do fieldwork with Indians

of the Southwest. Hired by the newly formed Bureau of Ethnology of The Smithsonian Institution, Cushing was a member of its maiden expedition which went to the Southwest in 1879. He left the expedition at Zuni pueblo, electing to live with the Zuni Indians for nearly five years.[3] Cushing's association with The University Museum began in 1895 when, plagued with ill health, he consulted Dr. William Pepper, a highly respected Philadelphia physician. Pepper, who was also the President of The University Museum's Board of Managers, arranged for Cushing to lead several expeditions, jointly sponsored by the Smithsonian and The University Museum, to the southwest coast of Florida.

Rio Grande blankets, woven on European style treadle looms by Spaniards who settled along the upper Rio Grande River, were not considered collectors' items and, therefore, were usually not well conserved, Surprisingly, a number of Rio Grandes in the collection are in excellent condition. Examples of both the striped and the banded varieties, as well as the type derived from the Saltillo sarape of northern Mexico number among the pieces. One Rio Grande blanket was collected by U. S. Hollister, who lived in Denver and traveled extensively throughout the Southwest in the late 1900s in order to acquire material for his collection.[4]

The Saltillo sarape, a finely-woven textile that had been worn in Mexico for several centuries, became extremely popular shortly after Mexican independence from Spain in 1821. Many Saltillos found in museum collections were acquired by United States military men engaged in the Mexican War of 1846–1848. One of the Museum's Saltillos was collected by a General Herring in 1845, while several others were purchased by George Byron Gordon in 1908.

Events that shaped the history of the Navajo people also affected their weaving. In 1863, the Navajo were interned at Bosque Redondo, New Mexico, by the United States government in an attempt to halt their continuous raiding in the Rio Grande Valley, When the Navajo returned to their homeland in 1868, although they continued to weave blankets and wear traditional clothing, the availability of commercial yard goods and blankets gradually changed their style of clothing.

By the last quarter of the nineteenth century, dramatic changes in Navajo textiles resulted, primarily from increased contact with the Anglo world. The introduction of new commercial yarns and dyes, along with exposure to alien design systems at Bosque Redondo, led to increased experimentation in their weaving. A gradual shift from weaving blankets to rugs developed when new markets for Navajo weaving were established. In this Transitional Period (1875–1890) different styles of blankets, blanket/rugs, rugs, and equipment for horses proliferated.

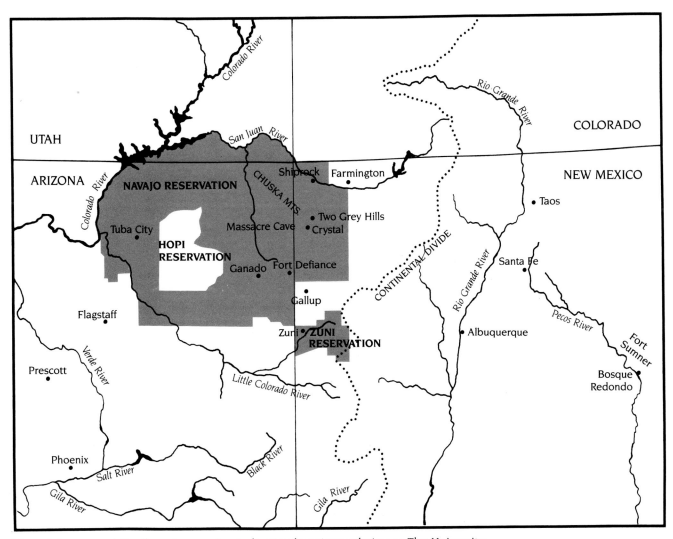

Map of the general Southwestern region indicating locations relating to The University Museum's textile collection.

Among the Museum's numerous transitional pieces are several eye-dazzlers, so-called for their busy patterns and bright aniline-dyed yarns, and a number of Germantown rugs woven with cotton twine warps and commercial yarns. All varieties of horse equipment are found in the collection, including single and double saddle blankets, throws, and cinches.

Early regional styles of Navajo rugs are represented in the collection, including Ganado, a style established in the region around Hubbell's Trading Post in Ganado, Arizona, and Two Gray Hills, named for the trading post south of Shiprock, New Mexico. There are also several Crystal rugs, a style inspired by J. B. Moore, a trader at Crystal, New Mexico. There is only one example of an early storm pattern rug woven in the western region of the Navajo Reservation, and one Yei rug, a style that originated in northwestern New Mexico.

The strength of The University Museum collection lies in the fact that it is a good cross-section of Southwestern textiles. Although not all early regional styles of Navajo rugs are represented and there are no examples of contemporary Navajo weaving, the collection is still remarkably comprehensive. The Museum anticipates adding other textiles which will round out the collection.

NOTES

1. Malone, Dumas, ed., *Dictionary of American Biography*, vol. 20 (New York: Charles Scribner's Sons, 1936), 47.
2. Wright, Barton, *Hopi Material Culture* (Flagstaff: Northland Press and the Heard Museum, 1979), 2.
3. Cushing, Frank Hamilton, *Zuni: Selected Writings of Frank Hamilton Cushing* (Lincoln: University of Nebraska Press, 1979), 5.
4. Hollister, Uriah S., *The Navajo and His Blanket* (1903; reprint, Glorieta, NM: The Rio Grande Press, Inc., 1972), preface.

All ethnographic photographs in the catalogue are from The University Museum's Photographic Archives.

Photos	Neg. Nos.
Manuelito	99134
Juanita	99131
Hopi weaver (man)	1718
Navajo weaver (woman)	1512
Navajos in shelter	1513
Navajo country	1619

THE GIFT OF SPIDERWOMAN
by
Joe Ben Wheat

When Coronado and his band of Spanish explorers entered what is now Arizona and New Mexico in 1540, instead of the gold and jewels they were seeking, they found numerous villages of Indians who lived in multi-roomed stone and mud houses often several stories high. The people of these villages, which are called *pueblos* in Spanish, farmed large tracts of land, raising maize, pumpkins, beans, and other plants including cotton, which they wove into clothing for themselves and which they traded to the "wild" Indians for dried meat, buffalo hides, and other things.[1]

Cotton was introduced from Mexico to the Indians of southern Arizona and New Mexico about the time of Christ, and by about A.D. 800 it had spread north to the ancestors of the modern Pueblo Indians, as well. Shortly afterward, the back-strap loom was introduced, on which the Pueblos wove narrow strips of cloth and belts. By A.D. 1100, the Pueblos had developed a wide, vertical, heddle-operated loom, and were weaving shirts, kilts, and breech cloths for the men, and for the women, a manta or dress which was wrapped around the body under one arm and fastened over the opposite shoulder, and belted around the waist. Both men and women wore the manta as a shawl around the shoulders in cold weather.[2] These mantas were wider than long, the length being measured along the warps, and were decorated by painting, embroidery, or by woven stripes in different colors (Plate 1). Mantas were frequently given to the Spanish explorers and later became a standard item of tribute to the Spanish settlers.[3]

In 1598, the Spanish, under Don Juan de Oñate, founded the first European settlement along the Rio Grande in New Mexico. They brought with them nearly 3,000 sheep.[4] These were to provide meat, and wool for weaving on home-made versions of the European treadle loom. These sheep were the common Spanish sheep, the *churro*, rather than the fine-fleeced merino,[5] and ranged in color from a creamy white through dark tans to almost black. The Spanish also brought indigo blue dye and perhaps other commercial dyes. By the 1630s, they were weaving a variety of coarse woolen cloths and blankets that were longer than wide.[6] The cloths were plain or woven with checks and plaids, while the blankets frequently had alternating stripes of blue and brown, together with white. Sometimes they were in other colors, dyes having been taken over from the Pueblos (Plate 2).

Spanish priests were assigned to the various Pueblo villages, and with the priests went sheep. By about 1625, the Pueblos were weaving with wool[7] as well as with cotton, and in time, cotton came to be used almost exclusively for ceremonial garments, while wool was used for weaving blankets and for everyday clothing. Blue- and black-striped long blankets with white or other colors were woven (Plate 3), modeled after those of the Spanish, and the pattern

came to be known as Moqui (after the Spanish name for the Hopi Indians). The wide manta, made from wool and decorated as before, became the most common article of dress among the Pueblos (Plate 4).

Most of the "wild" Indians who lived around and between the settled Pueblos were warlike Apache tribes who belonged to the widespread Athapascan family.[8] They were mostly hunters, gatherers, and raiders who were seminomadic. They had come to the Southwest long after the Pueblos but before the Spanish arrived. One such Apache tribe, living in the mountainous area northwest of the Spanish capital of Santa Fé, did practice agriculture. These were the Apaches de Navaju (Apaches of the big fields), later known simply as Navajo. When they enter the historical record in 1626, they were not known as weavers of cloth but probably were already weavers of the fine baskets for which they later became famous.

According to Navajo legend, it was Spiderwoman who taught them to weave. It is not known exactly when the Navajo became weavers, but by 1640, they had stolen flocks of sheep from along the Rio Grande in retaliation for the warfare of the Spanish against them.[9] At this same time, there were numerous Pueblo Indians who, having fled from Spanish persecution, found refuge with the Navajo. Thus, it was probably during the middle of the 17th century that the Navajo learned to weave—from Spiderwoman in the guise of Pueblo refugees. The Navajo took over not only the Pueblo vertical loom but all of the other weaving tools and techniques as well. It is not surprising, then, that the Navajo also took over the most common loom products of the Pueblos—the belt, the shirt, and the manta dress-shawl and cloth.

When in 1680 the Pueblos revolted and drove the Spanish out of New Mexico, the Navajo sided with the Pueblos. The Spanish reconquered New Mexico between 1692 and 1696, and many Pueblos again fled to the Navajo's homeland and lived with them.[10] In 1706 the Spanish first mention weaving by the Navajo, noting that they dress like the Christian Indians—the Pueblo—in the wide black manta dress with blue edges, and that they weave a surplus of cloth and clothing (and baskets) which they trade to the Pueblos and to the Spanish alike for other things that they need.[11]

By the mid 18th century, Navajo weaving had changed in many ways. The old Pueblo manta one-piece dress was giving way to a two-piece dress with identical front and back blankets, perhaps copies of their ancient two-piece skin dress. At the ends, decorated panels of red replaced the blue,[12] the red weft threads being raveled from a solid red commercial cloth called bayeta—Spanish for baize. This was because the Navajo had no good red dye. Bayeta was commonly given to the Navajo by the Spanish when they were at peace or was traded from the Pueblos. The Navajo retained the manta as a shawl or small shoulder blanket. They also began to weave their blankets a segment at a time instead of straight across from side to side, leaving diagonal "lazy" lines

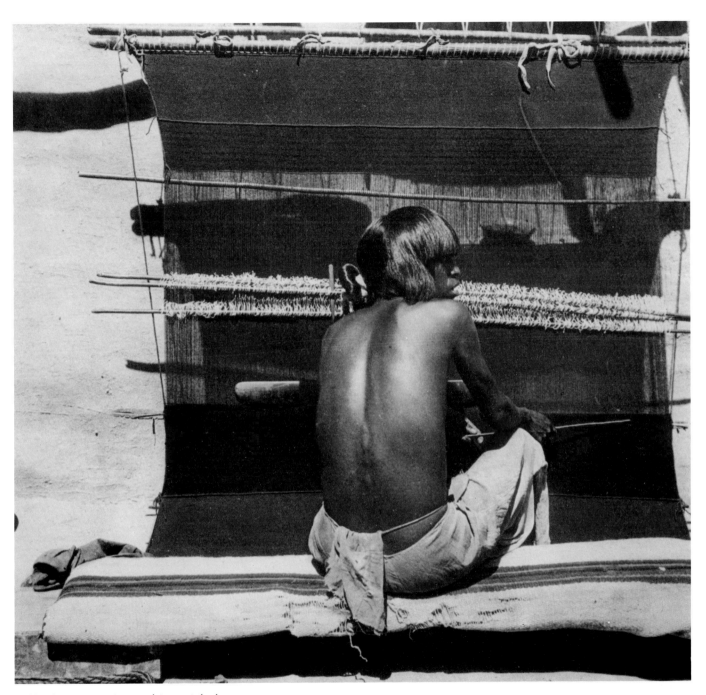

A Hopi man weaving on his upright loom.

between the adjacent sections; and rather than selvages woven with three two-ply cords and loose corners, they began to use two three-ply cords tied tightly at the corners. Furthermore, while the Pueblos continued mainly to weave balanced plain and balanced diagonal and diamond twill weaves in which both warp and weft can be seen, the Navajo began more and more to use weft-faced or tapestry weaves in which the thicker, softer weft conceals the warp. The design potential of the tapestry weave is enormous, and the Navajo, probably copying their fine baskets, began to weave terraced triangles and diamonds into their cloth. By 1800 the woman's two-piece dress had terraced designs at the ends, woven in indigo blue on a raveled red cloth ground[13] (Plate 5). (Textile fragments found in Massacre Cave, Arizona, where a group of Navajo were killed by Spaniards in 1804, have provided information about Navajo clothing worn during this period.)

The Navajo continued to weave shoulder blankets in the Pueblo wider-than-long style. At first these were simply decorated by alternating black and white stripes, but by 1800, they had widened the black stripes at the ends and center, adding a pair of blue stripes across the ends and two pairs across the center[14] (Plate 6). This simple but elegant blanket came to be known as a First Phase Chief blanket, although it had no connection to the rank of the wearer. Because it was a favored trade item for the Ute Indians, it is sometimes also called a Ute Blanket. Later First Phase blankets sometimes had narrow red edging along the blue stripes.

Sometime about 1850, shortly after the United States took over New Mexico from Mexico, some weavers began to weave small rectangles of red at the ends of the blue stripes, creating a twelve-spot pattern known as a Second Phase Chief pattern (Plate 7). By 1860 several variations of the twelve-spot pattern had developed, and shortly thereafter, the design elements began to encroach on the field of alternating black and white stripes between the ends and center panels. By 1865 a large terraced diamond was placed in the center of the blanket, with quarter-diamonds at each corner and half-diamonds at the center of the ends and sides, making a nine-spot pattern. This Third Phase Chief blanket adapted the terraced diamonds that had long been used in other kinds of blankets (Plate 8).

In addition to the woman's manta shawl, which had the same patterns as the two-piece dress, a number of women's shoulder blankets followed the same pattern development as the man's Chief blanket except that they were smaller, and rather than wide black and white stripes, the field between the end and center panels consisted of narrower black and gray stripes, the gray being made by carding together black and white wool (Plate 9).

Even though the Navajo have continued to weave fabrics in the old Pueblo format, their finest weaving was in the longer-than-wide format adopted from the Spanish sarape or wearing blanket. Most likely the earliest Navajo sarapes were

decorated with stripes, like those of the Spanish and Pueblos. Stripes were especially appropriate for the common everyday utility blanket, called *diyugi* (soft, fluffy) by the Navajo, that was used as a bed blanket at night, a wearing blanket by day, and a wrap for firewood, clipped wool, or baby, as necessary (Plates 10, 11). Dozens of these utility blankets were woven, worn out, and discarded for every one of the superb sarapes worn on special occasions, which represent the finest weaving ever done in the Southwest.

The period between the early decades of the 19th century and about 1860 can properly be termed the Classic Period in Navajo weaving. Most of the Classic sarapes had a crimson background of weft yarns raveled from a fine-threaded worsted baize or bayeta of unknown origin, dyed with lac or lac mixed with cochineal, with designs woven in indigo blue and white. Only rarely was any other color used. Regardless of the visual complexity of the piece, the designs consisted only of stripes and terraced triangles, solid or hollow diamonds, and zigzags arranged in rows so as to form an overall pattern. Often the contrast between, and placement of, terraced figures of blue or white formed negative patterns as well. Most of these blankets were woven as sarapes, but a few were made as ponchos with a slit left in the center for the head of the wearer (Plate 12).

All during the Classic Period, New Mexico was in a state of turmoil.[15] In 1821 Mexico won its independence from Spain and opened its northern frontiers to commerce from the United States across the Santa Fé Trail. This trade burgeoned, and when the Mexican War began in 1846, the Americans took over New Mexico and the rest of the Southwest. The Navajo, taking advantage of the turmoil of these years, continued to conduct raids in the Rio Grande Valley. Finally, in 1863, the Navajo were defeated by American troops under Kit Carson and were exiled to a reservation at Bosque Redondo in the arid Pecos River Valley in eastern New Mexico. The exile continued for five years, during which time the Navajo underwent many changes. Because they had few sheep left, they were furnished with commercial yarns and a soft, thick woolen bayeta, as well as cotton prints. Their clothing began to change, and more and more of their weaving became destined for commerce and less and less for themselves.

During the late Classic Period, which began in the early 1860s largely at Bosque Redondo, many of the terraced design elements of the earlier Classic persisted, often, in fact, became more elaborate, but there was a tendency for them to be arranged in neat, tightly defined, separate bands and very often with designs of red or blue on a white ground (Plate 13). More and more colors appeared. The red color now came from raveled woolen bayeta usually dyed with cochineal, or from early three-ply commercial yarns. Other colors such as green, yellow, and lavender also appeared. New design elements, largely taken from other basketry patterns, began to appear in their blankets. Meanders, simple and complex crosses, chevrons, and short vertical zigzags arranged as a

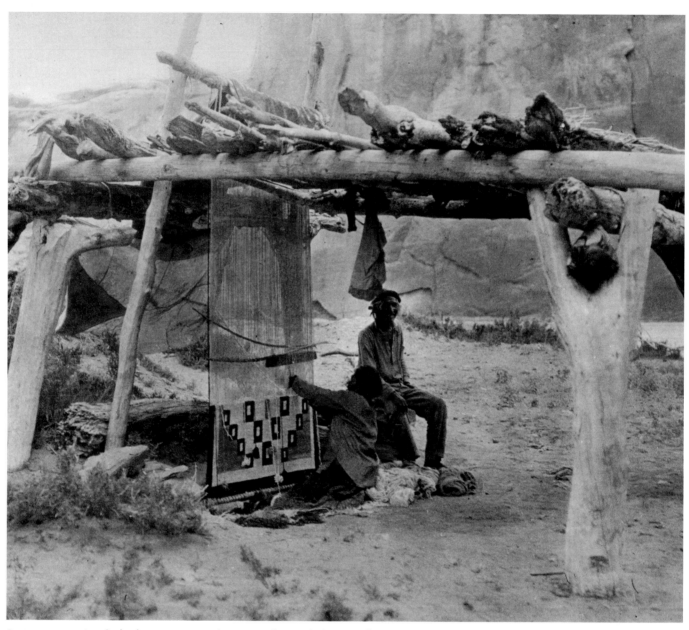

A structure, using forked trees as uprights, served as a shelter for the weaver's loom.

horizontal stripe supplemented and sometimes replaced the older terraced figures (Plate 14). When terraced figures were used, they were frequently made by alternating short stripes of different colors (Plate 15) to form the edges of the terraces. Occasionally, terraced zigzag stripes were used alone to decorate a blanket (Plate 16).

During their stay at Bosque Redondo, the Navajo came into greater contact with blankets woven by the Spanish weavers of the Rio Grande Valley, and when they were allowed to return to their own country in 1868, they took with them the seeds of an alien design system. In the late 1500s, a group of Tlascalan Indians from near Mexico City was sent to the Saltillo area of northern Mexico to help tame the "wild" Indians, teaching them agriculture and weaving in the process. By the mid 1700s, they had developed the superb Saltillo sarapes and ponchos with large, finely figured concentric diamonds with serrate edges in the center, figured borders, and a background of geometrically placed dots (Plate 17) or vertically oriented zigzags and small "butterfly" figures (Plate 18). Sometime around 1800, the Spanish in the Rio Grande began to copy the Saltillo designs, but because their yarns were less fine and they lacked the sophisticated dyes of the Saltillo, these were vastly simplified (Plate 19). It was the simplified version of Saltillo design that the Navajo began to adapt to their own weaving about 1870.[16]

Navajo design had always consisted of stripes, bands, or terraced figures that reached from edge to edge of the field without borders. They did not adopt all of the new serrate features at once. Rather, they modified the old terraced forms by substituting serrate edges on the triangular figures at the ends of their blankets (Plate 20) or by extracting the diamond stripe, which was used as an edging device in the Saltillo sarapes, and using it as a regular stripe combined with traditional elements in their own weaving (Plate 21). Sometimes the Navajo would extract the vertical zigzag background of the Spanish weaving and use it, often rearranged, as the entire decorative scheme of a blanket (Plate 22). Where the Navajo had previously used a concentric terraced diamond, as in the Third Phase Chief blanket, they now sometimes substituted the concentric serrate Saltillo diamond (Plate 23). By 1885 blankets with serrate figures and some form of border dominated Navajo design, although the earlier stripes and terraced figures were never abandoned entirely.

Just as this transitional style was fully integrated into Navajo weaving, yet another change took place. Many of these later blankets began to be used as rugs by the military and settlers from the eastern United States. The railroads brought new commercial shawls, and the Navajo found the new cotton and later velvet clothing more comfortable than that they had been weaving. It was possible to sell one blanket through the trading posts and, with the proceeds, buy the materials for several needed garments. The traders encouraged the Navajo to weave for this new clientele. The Navajo began to develop a number

of new styles. They developed a two-face weave that produced a rug with a different pattern on each face, and a type of eccentric weave, known as wedge-weave, in which parallel diagonal wefts were used to produce diagonal stripes, zigzags, or even diamonds across the fabric. Tufts of wool were inserted into the weft in such a way as to produce a rug with a tufted surface on one side—a kind of artificial sheepskin.

For a very long time, the Navajo had occasionally inserted pictorial elements into blankets that otherwise had a normal pattern of terraced or serrate figures. During this time, more blankets or rugs that were basically pictorial in content began to emerge. Sometimes, as if the weaver was not satisfied with a single composition, the space was broken into panels, each of which contained a different picture (Plate 24).

The most important change occurred about 1890 when a few of the traders began to get the Navajo to weave rugs. Oriental carpets, especially Caucasian carpets, were in fashion in the Victorian homes of the Midwest and East. The traders, especially J. L. Hubbell at Ganado, Arizona, and J. B. Moore at Crystal, New Mexico, persuaded their weavers to produce simplified copies of the Caucasian carpets. About the turn of the century, Moore sent out catalogues and fliers with colored plates of rug patterns from which the customer could select a pattern to be woven in his color choice and desired size. Hubbell had oil paintings made of favorite designs so that rugs could be ordered as desired. A favorite Hubbell pattern was one with large crosses at each end, surrounded by various elements, and enclosed in a figured border (Plate 25).

Many of the finest rugs of the turn of the century were woven with four-ply commercial yarn commonly called after Germantown, Pennsylvania, where much of it was manufactured. Germantown yarns came in a wide variety of colors, and rugs were commonly woven in many colors. Other rugs were woven of coarsely handspun yarns in neutral grays and tans, carded from black and white wools, or else dyed in rainbow colors with the garish aniline dyes of the day.

Twill weaves have always been a part of the Navajo weaving tradition. As the horse herds increased after the Navajo returned from Bosque Redondo, more and more thick, soft blankets of handspun yarns were woven to go under saddles. Although plain weave saddle blankets were also made, most early saddle blankets were of the twill weaves, and the various twill patterns came to be known as the saddle-blanket weaves (Plate 26).

Through almost four centuries, the Navajo weavers have been able to change with the times. They have borrowed but have always integrated the new with the old, making it their own. They have, as well, created innovations, and the Navajo women who weave for today's market weave as well as their grandmothers did. The Gift of Spiderwoman, although changed, continues today. Spiderwoman has been good to the Navajo.

NOTES

1. Hammond, George P. and Agapito Rey, eds. & trans., *Narratives of the Coronado Expedition, 1540–1542* (Albuquerque: University of New Mexico Press, 1940).
2. Kent, Kate Peck, *Textiles of the Prehistoric Southwest*, School of American Research, Southwest Indian Arts Series (Albuquerque: University of New Mexico Press, 1983).
3. Bolton, Herbert E., ed., *Spanish Explorations in the Southwest, 1542–1706* (Charles Scribner's Sons, 1916), 181–186, *passim*.
 Hackett, Charles W., ed. and trans., *Historical Documents Relating to New Mexico, Nueva Vizcaya and Approaches Thereto, to 1773*, 3 vols. (Washington: Carnegie Institution, 1923–37), III: 109–110.
4. Hammond, George P. and Agapito Rey, eds. & trans., *Don Juan de Oñate, Colonizer of New Mexico, 1595–1628*, 2 vols. (Albuquerque: University of New Mexico Press, 1953).
5. Wentworth, Edward N., *America's Sheep Trails* (Ames, Iowa: The Iowa State College Press, 1948), 123.
6. Bloom, Lansing B., "A Trade-Invoice of 1638," *New Mexico Historical Review*, 10 (1935): 242–248.
7. Towne, Charles W. and Edward N. Wentworth, *Shepherd's Empire* (Norman, Oklahoma: University of Oklahoma Press, 1945), 29–30.
8. Forbes, Jack D. *Apache, Navaho, and Spaniard* (Norman, Oklahoma: University of Oklahoma Press, 1960), xiii.
9. Worcester, Donald E., "The Navajo During the Spanish Regime in New Mexico," *New Mexico Historical Review*, 26 (1951): 106.
10. Forbes, *Apache, Navaho, and Spaniard*, 177–280.
11. Hackett, *Historical Documents* 3: 381–382.
 Hill, W. W., "Some Navaho Culture Changes during Two Centuries (with a translation of the Early Eighteenth Century Rabal Manuscript)" in *Essays in Historical Anthropology of North America*, Smithsonian Miscellaneous Collections, vol. 100 (Washington D.C.), 395–415.
12. Brugge, David, trans., Troncoso's Report of Escorting Antonio El Pinto to his Home, 1788, Internal Provinces, vol. 65, General Archive. (Ms.)
13. Amsden, Charles Avery, *Navaho Weaving: Its Technic and History* (Santa Ana, California: The Fine Arts Press, 1934), 140, Plate 49.
14. Wheat, Joe Ben, "The Navajo Chief Blanket," *American Indian Art Magazine*, vol. 1, no. 3: (Summer 1976): 44–53.
15. Underhill, Ruth M., *The Navajos* (Norman, Oklahoma: University of Oklahoma Press, 1956), 73–163.
16. Wheat, Joe Ben, "Saltillo Sarapes of Mexico," in *Spanish Textile Tradition of New Mexico and Colorado* (Sante Fé, New Mexico: Museum of New Mexico Press, Museum of International Folk Art, 1979), 74–82.

Plate 1 Woman's Manta Hopi c. 1885

Traditional cotton woman's manta in balanced diagonal and diamond twill weave. Warp: commercial cotton twine—white. Weft: handspun cotton—white; handspun wool—indigo-dyed blue; raveled red cloth—synthetic dye. 59-14-29.

30″×38″ (76 cm × 97 cm)

Plate 2 **Blanket** Spanish Colonial c. 1870

Softly woven blanket made on wide loom. Warp: two-ply handspun wool—white. Weft: handspun wool—dark brown, white, combed brown, indigo-dyed blue, indigo-dyed green, dyed yellow and tan. NA 9294.

90″×58″ (223 cm×147.5 cm)

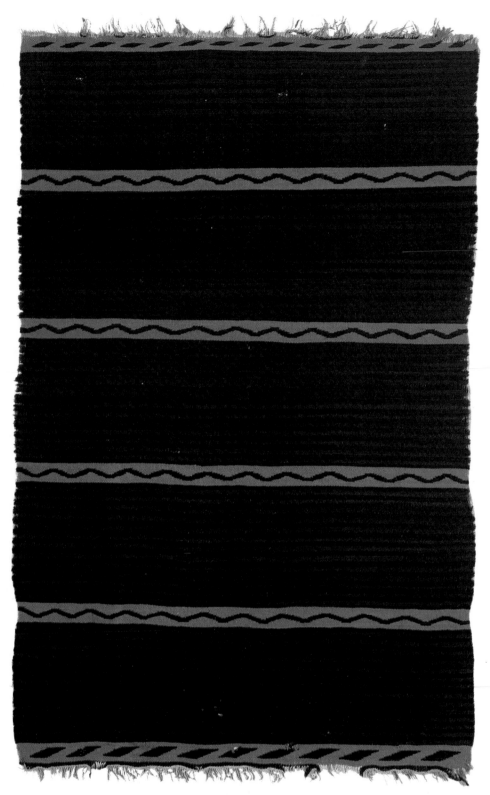

Plate 3 **Blanket** Zuni c. 1860–1870

Soft blanket for wearing, woven in the Moqui Pattern. Warp: handspun wool—white, doubled on edges. Weft: handspun wool—natural dark brown, indigo-dyed blue; raveled red—coarse, synthetic dye. NA 3480.

73"×46.5" (185.5 cm × 118 cm)

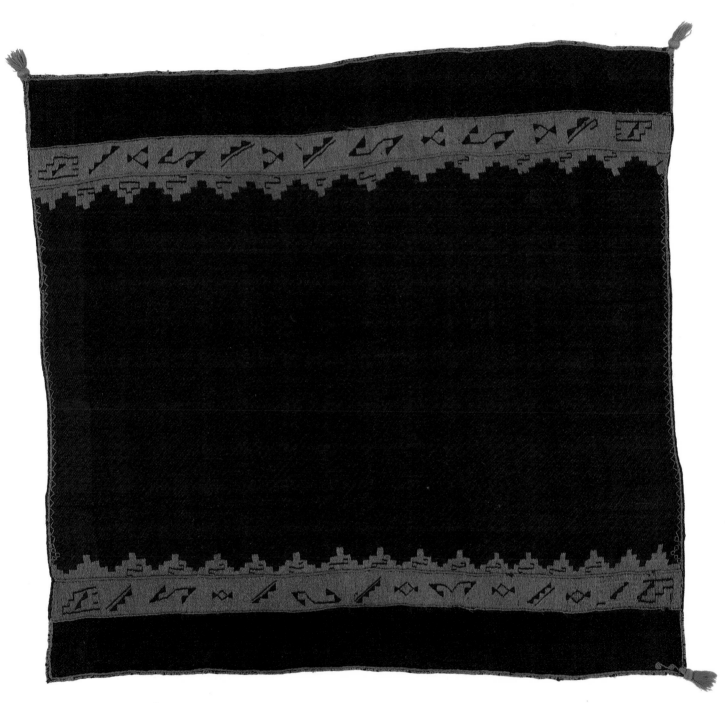

Plate 4 **Embroidered Manta** Zuni c. 1850

Zuni mantas with red embroidery, rather than dark blue, are very rare. Embroidered mantas were worn as shawls on special occasions. Balanced diagonal and diamond twill weave. Warp: handspun wool—black. Weft: handspun wool—black, indigo-dyed blue. Embroidery: raveled bayeta—crimson, cochineal- and lac-dyed. 29-138-2.

51″×54″ (130 cm×137 cm)

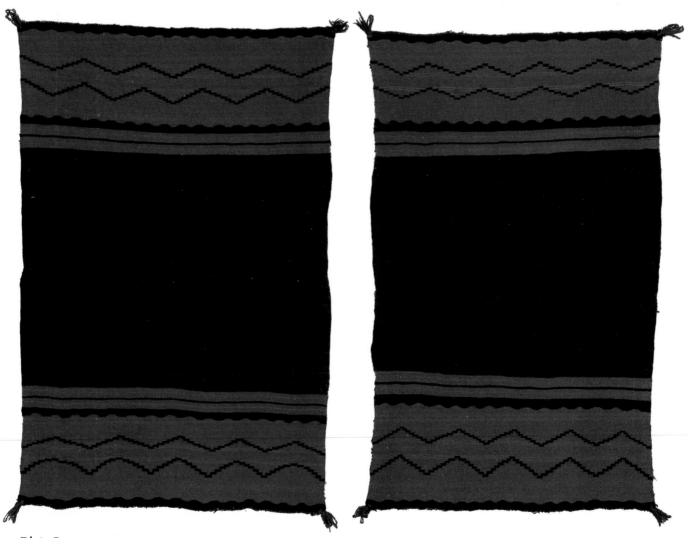

Plate 5 Two-piece Dress Navajo c. 1860–1870

Standard woman's dress with Classic terraced zigzag blue stripes on red end panels. The two-piece dress was everyday wear from about 1775 until 1900. Warp: handspun wool—white. Weft: handspun wool—black, indigo-dyed blue; raveled bayeta—crimson, dyed with cochineal and lac. 29-138-1-a and 1-b.

52″×30″ (132 cm×76 cm) & 51″×34″ (129.5 cm × 86 cm)

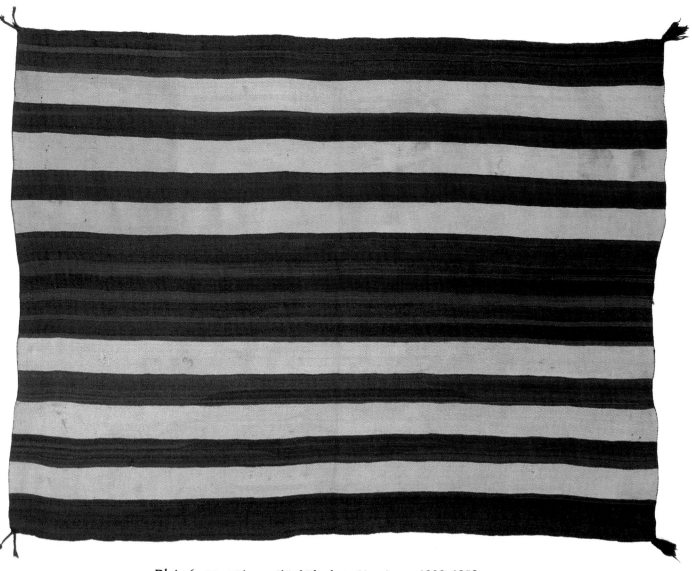

***Plate* 6** **First Phase Chief Blanket** Navajo c. 1800–1850

Broad black end and center panels with paired blue stripes mark this early form of man's shoulder blanket derived from the striped Pueblo manta. Because the Ute Indians acquired many of these blankets, the pattern is sometimes termed the Ute Style. Warp: handspun wool—white. Weft: handspun wool—white, black, indigo-dyed blue. NA 3477.
59.5″ × 79″ (151 cm × 201 cm)

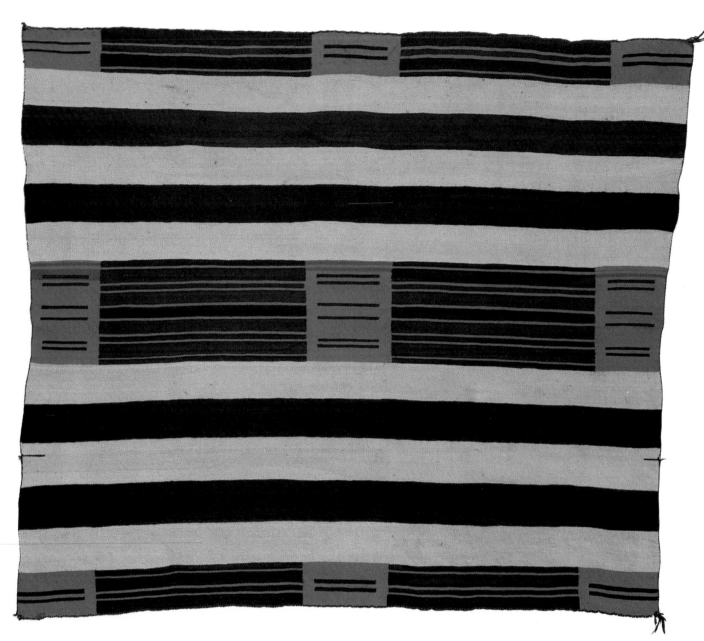

Plate 7 **Second Phase Chief Blanket** Navajo c. 1865–1870

Red blocks at the ends of the blue stripes mark the Second Phase Chief blanket. Many of these were traded to the Plains Indians. Warp: handspun wool—white. Weft: handspun wool—white, black, indigo-dyed blue; raveled bayeta—cochineal-dyed; three-ply wool commercial yarn—red, synthetic dye. NA 8431.

57.5″ × 66″ (146 cm × 167 cm)

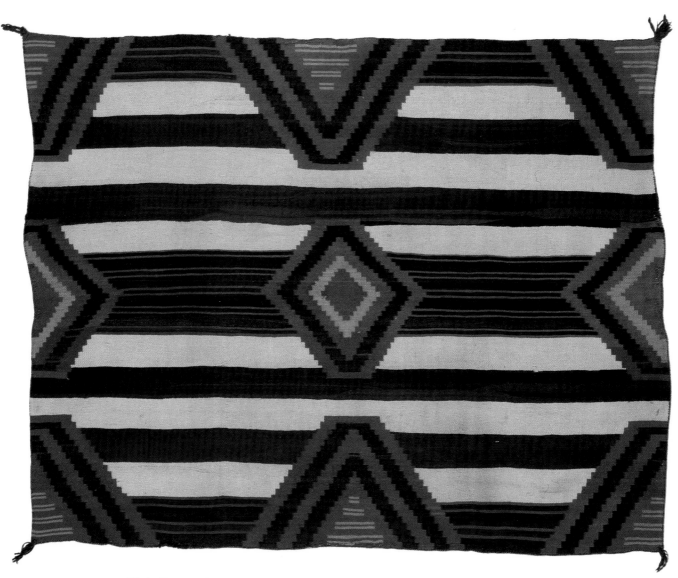

Plate 8 Third Phase Chief Blanket Navajo c. 1870

Third Phase Chief blankets have terraced concentric diamonds, half- and quarter-diamonds which extend into the field of broad black and white stripes. Warp: handspun wool—white. Weft: handspun wool—white, black, indigo-dyed blue; raveled bayeta—crimson and maroon dyed with cochineal; green, unknown dye. NA 3476.

54.5″ × 70″ (138.5 cm × 178 cm)

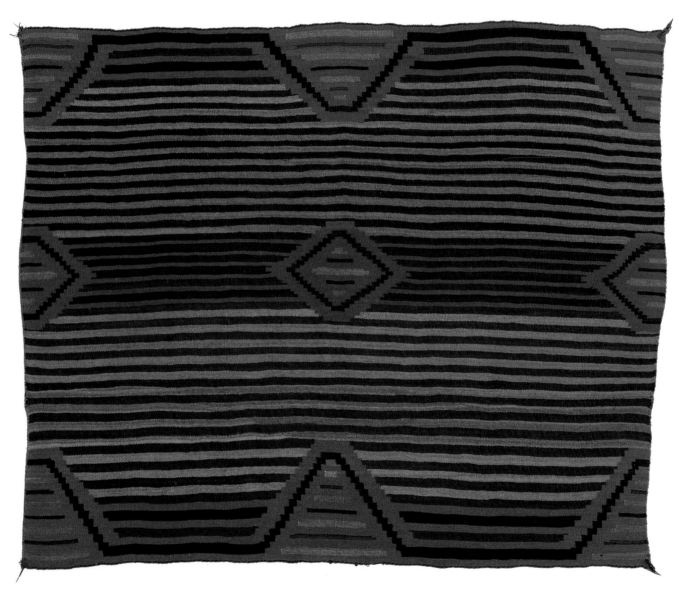

Plate 9 **Third Phase Woman's Blanket** Navajo c. 1870–1875

Women's shoulder blankets have narrow black and gray, rather than wide black and white, body stripes. Warp: handspun wool—combed gray. Weft: handspun wool—black, combed gray, combed pink, indigo-dyed blue; respun—crimson, cochineal-dyed; raveled bayeta—2 kinds of cochineal-dyed crimson; three-ply commercial yarn—crimson, cochineal-dyed. NA 59-14-36. 47.5″ × 59.5″ (120 cm × 151 cm)

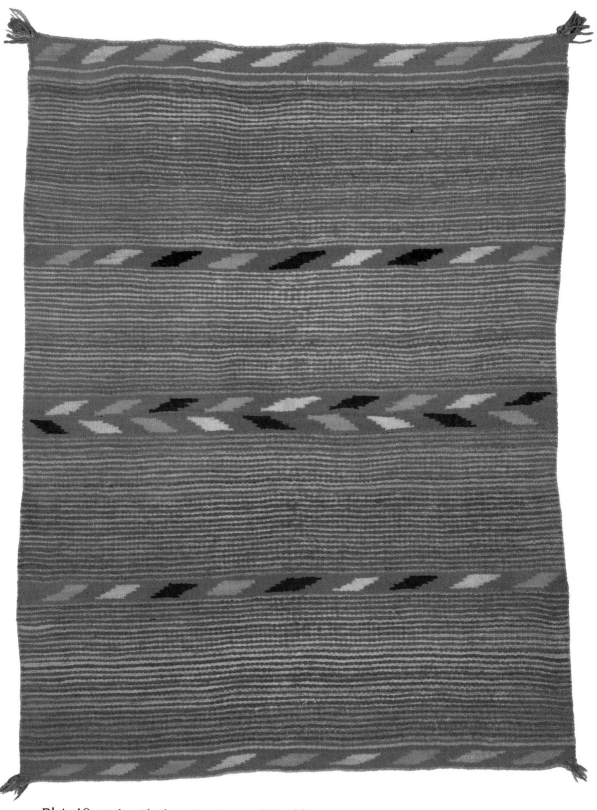

Plate 10 Utility Blanket Navajo c. 1875–1885

Softly woven striped blanket of many uses, termed *diyugi* (soft, fluffy) by the Navajo. Warp: handspun wool—white. Weft: handspun wool—white, black, combed gray, synthetic-dyed reddish brown and yellow; respun—tomato red, synthetic dye. NA 3917.

56″ × 42″ (143 cm × 107 cm)

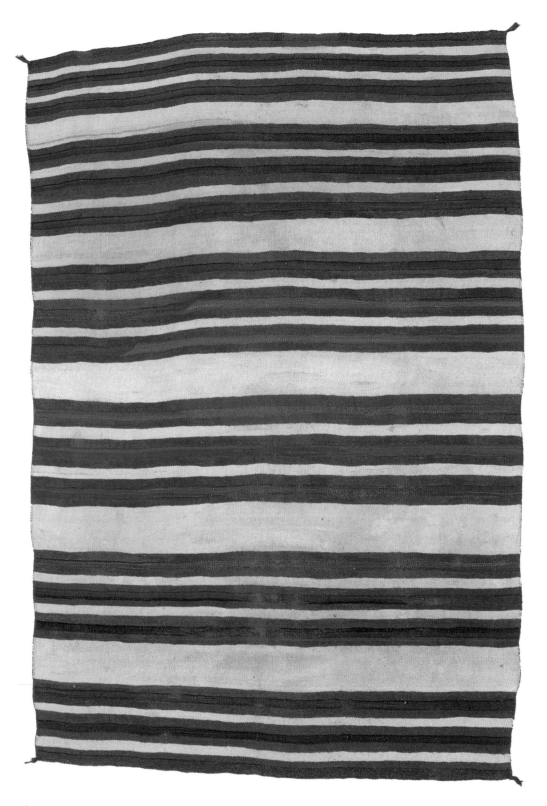

Plate 11 **Sarape** Navajo c. 1860–1870

Late Classic striped sarape. Warp: handspun wool—white. Weft: handspun wool—white, indigo-dyed blue; raveled bayeta—crimson dyed with cochineal and lac. NA 59-14-38.
72.5″ × 49″ (184 cm × 124 cm)

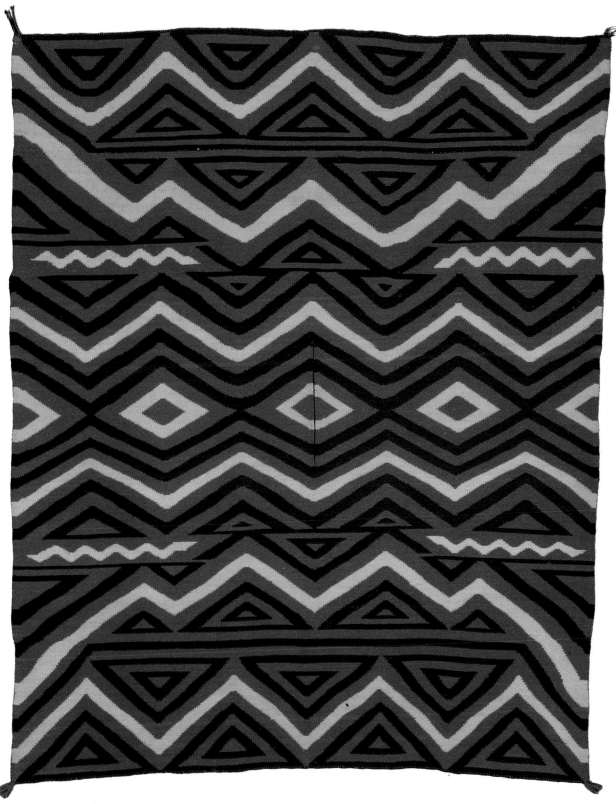

Plate 12 **Classic Poncho Sarape** Navajo c. 1850

Fine poncho sarape. Full Classic design of terraced concentric triangles, diamonds, and zigzags arranged in an all-over integrated composition in crimson, blue, and white. Warp: handspun wool—white. Weft: handspun wool—white, indigo-dyed blue; raveled worsted bayeta—crimson, lac and cochineal dye. NA 76-23-1.

69.5″ × 57″ (176.5 cm × 14.5 cm)

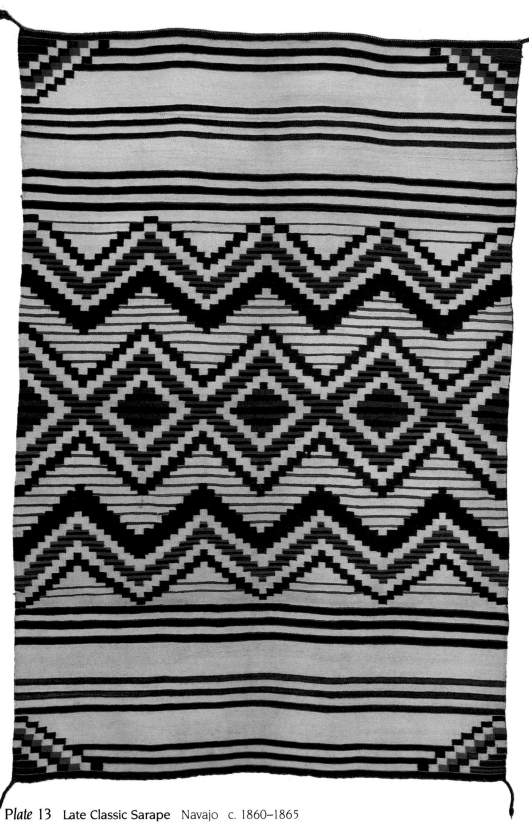

Plate 13 Late Classic Sarape Navajo c. 1860–1865

Fine sarape with terraced concentric diamonds and zigzags in the broken-striped technique in red, blue, and black, on zoned white ground. Warp: handspun wool—white. Weft: handspun wool—white, brown-black, indigo-dyed blue; raveled bayeta—crimson, cochineal and lac dye. NA 5873.

69″ × 47″ (174.5 cm × 119.5 cm)

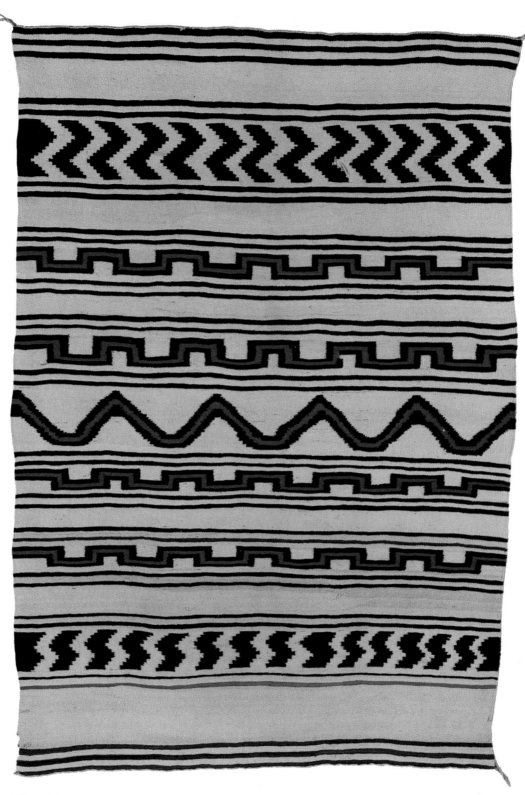

Plate 14 Late Classic Sarape Navajo c. 1860–1865

Sarape collected at Fort Union, New Mexico, before 1865 by Colonel William Potter Wilson. Late Classic design innovations of meander and vertical zigzag stripes in red and blue on zoned white ground. Warp: handspun wool—white. Weft: handspun wool—white; raveled— indigo-dyed blue, crimson dyed with lac and cochineal. NA 64-6-1.

74.5″ × 52.5″ (189.5 cm × 133 cm)

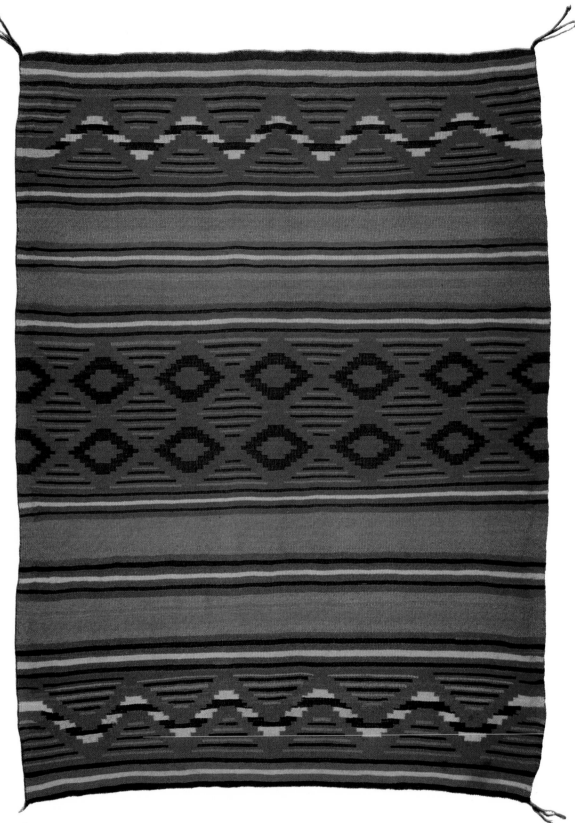

Plate 15 Late Classic Child's Blanket Navajo c. 1870

Small sarape with typical Late Classic design of rows of small, open diamonds, with terraced triangles and zigzags in broken stripe technique on a carded pink ground. Warp: handspun wool—white. Weft: handspun wool—white, indigo-dyed blue, carded pink; three-ply commercial wool—crimson, cochineal dye. NA 59-14-34.

39″×29.5″ (99.5 cm × 75 cm)

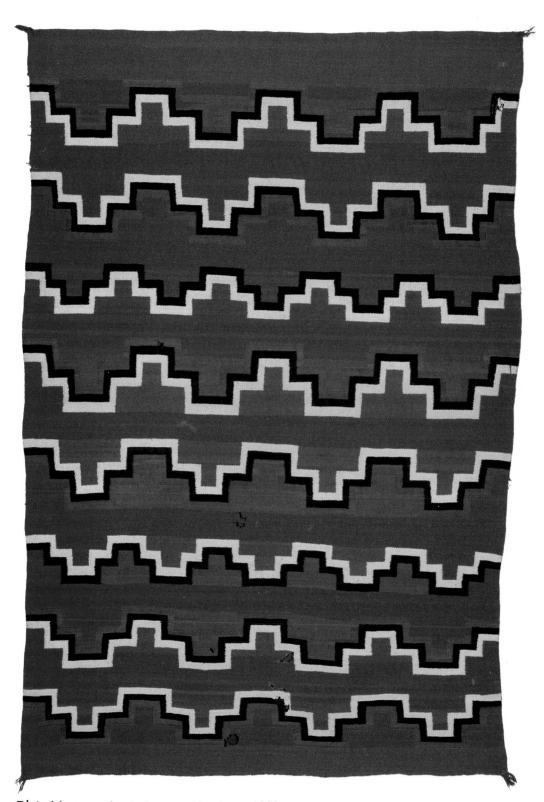

Plate 16 Late Classic Sarape Navajo c. 1880

Sarape woven from late raveled cloth, with concentric large-scale meanders on a red ground. Warp: handspun wool—white. Weft: handspun wool—white, indigo-dyed dark blue, indigo-dyed green; raveled—light and dark crimson, synthetic dyes. NA 8436.

78″×53″ (197.5 cm × 135.5 cm)

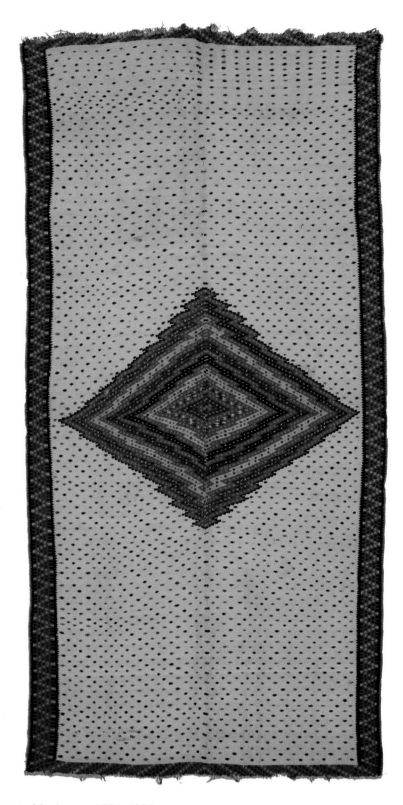

Plate 17 Saltillo Sarape Mexico c. 1775–1800
Polychrome concentric serrate diamond central figure on white ground with gridded pattern
surrounded by patterned border. Warp: handspun two-ply cotton—white. Weft: handspun
wool—white, black, dyed yellow, indigo-dyed blue, cochineal-dyed dusky pink and crimson.
39-5-1.
94″×48″ (238 cm × 122 cm)

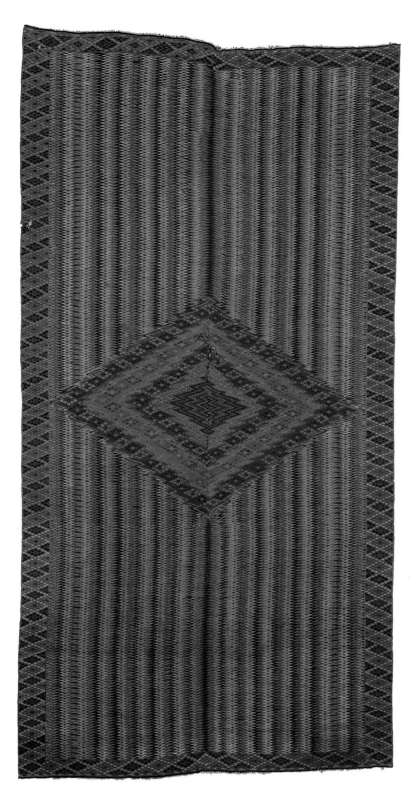

Plate 18 Saltillo Poncho Sarape Mexico c. 1775–1800

Fine polychrome Saltillo sarape with figured concentric serrate diamond center, figured border, and figured ground with very complex vertical serrate zigzag and interlocking diamonds. Warp: handspun two-ply cotton—white. Weft: handspun wool—white, dyed ecru, yellow, khaki-green, dark and light indigo-dyed blue, cochineal-dyed dusky pink and crimson. NA 9274.
91″×49″ (231 cm × 124 cm)

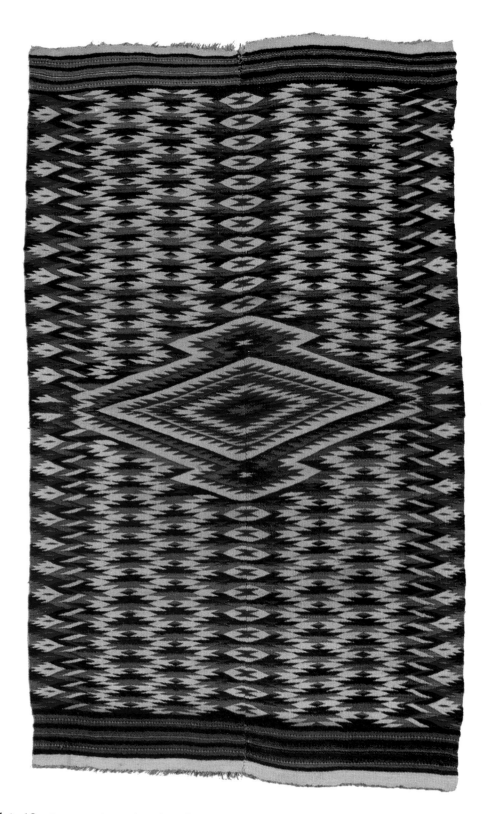

Plate 19 **Sarape** Spanish Colonial c. 1860–1870

Rio Grande Spanish Colonial copy of Saltillo sarape. Rio Grande blankets were widely traded to
Mexico, California, and the Plains and Southwestern Indians. Warp: handspun two-ply wool—
white. Weft: handspun wool—white, brown-black, indigo-dyed blue; commercial three-ply
wool—crimson, cochineal dye. NA 9102.

72″×47″ (183 cm × 119.5 cm)

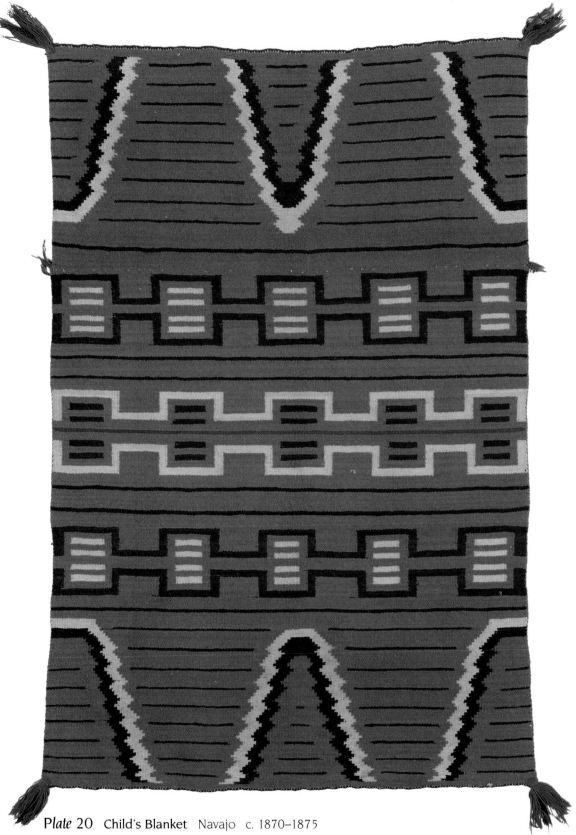

Plate 20 Child's Blanket Navajo c. 1870–1875

Small sarape with Late Classic design elements. End diamond figures done in modified Saltillo serrate style. Warp: handspun wool—white. Weft: handspun wool—white, indigo-dyed blue; raveled—coarse, dull red, synthetic dye. NA 3478.

46″ × 30.5″ (117 cm × 77.5 cm)

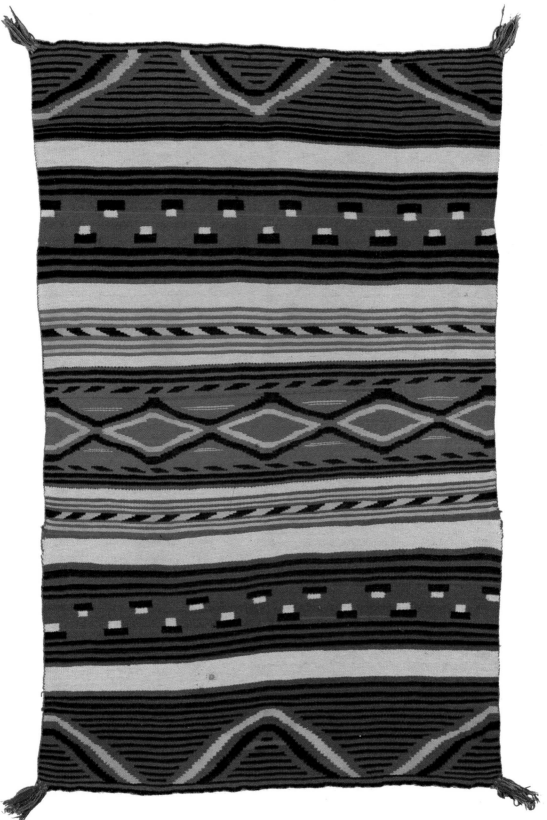

Plate 21 **Child's Blanket** Navajo c. 1870

Late Classic pattern with diamond stripe figures derived from the Saltillo style. Warp: handspun wool—white. Weft: handspun wool—white, indigo-dyed blue; commercial three-ply wool—light red and crimson dyed with cochineal, light green, synthetic dye. NA 8434.

49″ × 31″ (124.5 cm × 78.5 cm)

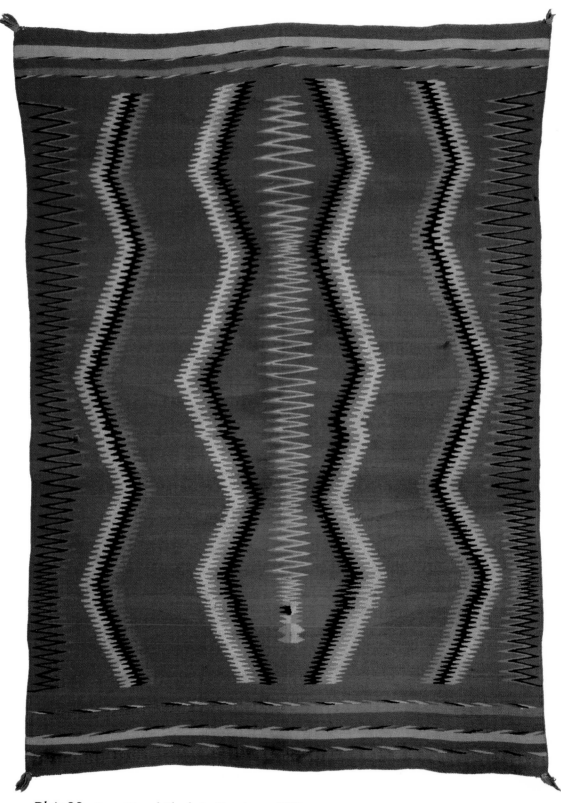

***Plate* 22** **Transitional Blanket** Navajo c. 1885

Finely woven blanket of Germantown yarn with vertically oriented serrated zigzag stripes adapted from the Saltillo style. Warp: commercial cotton twine—white. Weft: commercial four-ply wool—white, undyed; synthetic-dyed black, red, green, yellow. NA 2485.

72″×51″ (183 cm × 129 cm)

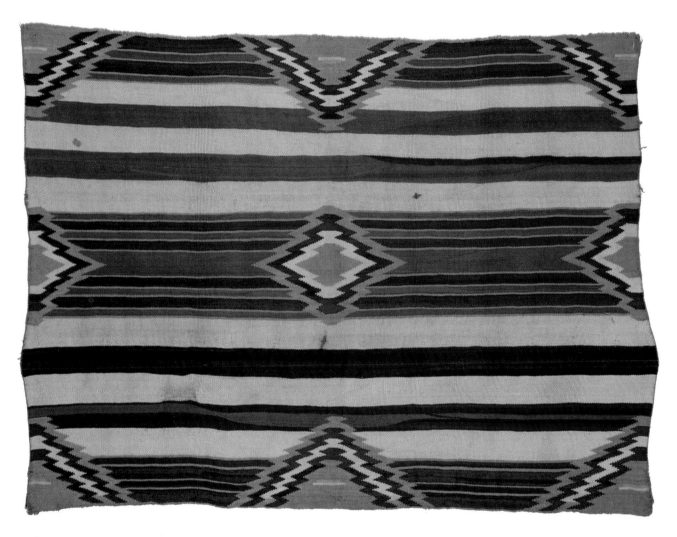

Plate 23 **Third Phase Chief Blanket** Navajo c. 1875

Serrate concentric diamonds take the place of the traditional terraced diamonds, reflecting the Saltillo tradition. Warp: handspun wool—white. Weft: handspun wool—white, brown-black, indigo-dyed blue; raveled—coarse, red, synthetic dye; commercial three-ply wool—pale yellow, light green, synthetic dyes. NA 9293.

60″×44″ (152.5 cm × 112 cm)

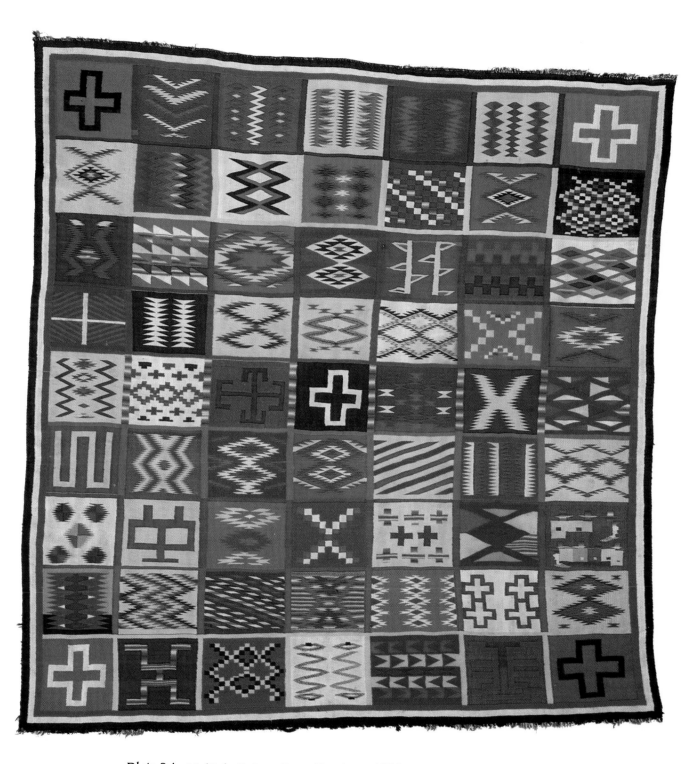

Plate 24 Multiple Pattern Rug Navajo c. 1885

Sixty-three panels, each with a different pattern except the center and four corner squares.
Most elements are geometric, with one railroad pictorial panel. This rug contains a veritable
sampler of preferred designs of the times. Warp: commercial cotton twine—white. Weft:
commercial four-ply wool—white, synthetic-dyed black, red, blue, green, lavender, yellow, tan,
reddish-brown, speckled. L 74-3-1.

73.5″ × 69.5″ (185.5 cm × 177 cm)

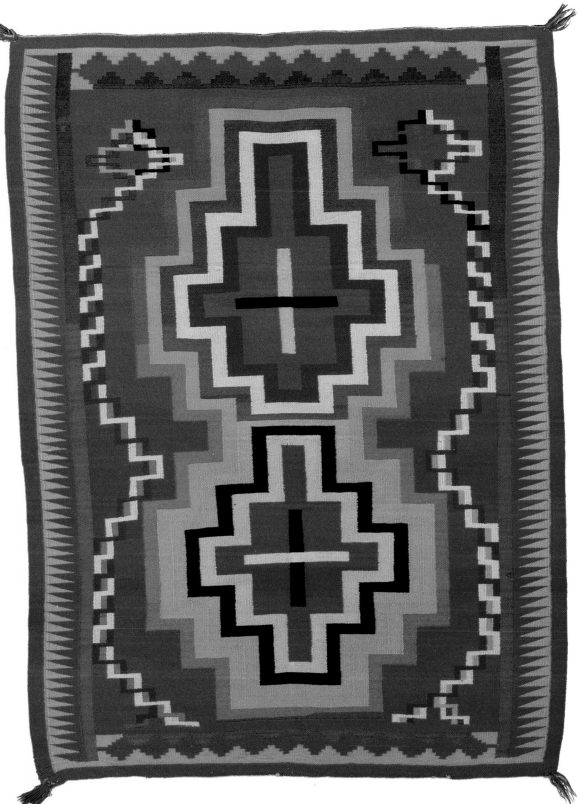

Plate 25 Germantown Rug Navajo c. 1900

Woven near Hubbell's Trading Post from one of the rug paintings from which the customer
could select pattern, adding his color scheme and size. The two large crosses in a bordered rug
was one of Hubbell's favorite designs. Warp: commercial cotton twine—white. Weft: commercial
four-ply wool—white, synthetic-dyed black, red, maroon, purple, green, yellow, tan. NA 39-8-33.
76″×53″ (193 cm × 134.5 cm)

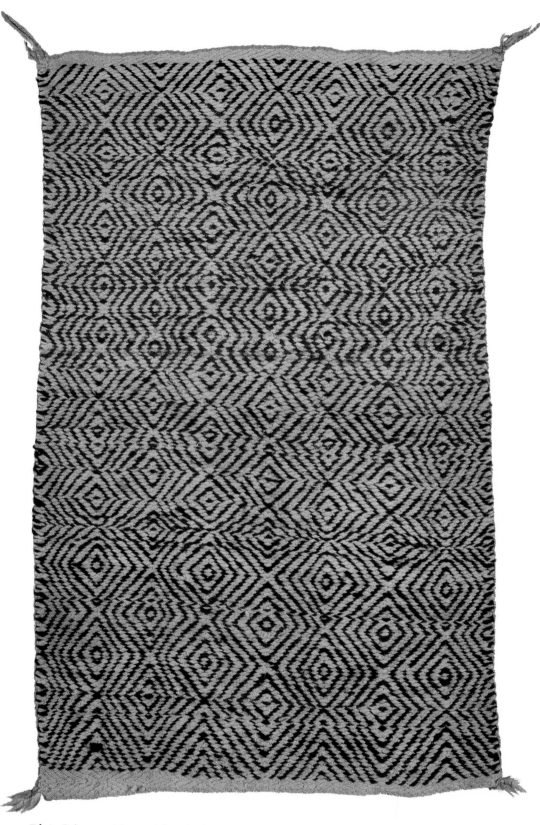

***Plate* 26 Double Saddle Blanket** Navajo c. 1885–1890

Double saddle blanket in weft-faced diamond twill weave. Saddle blankets are one of the few
fabrics the Navajo still weave for themselves. Warp: handspun wool—white. Weft: handspun
wool—white, brown-black, synthetic-dyed orange in selvage. NA 67-37-3.
47.5″ × 32″ (120 cm × 81 cm)

SUGGESTED READING

Amsden Charles Avery
 1949 *Navaho Weaving: Its Technic and History*. 2d ed. Albuquerque: University of New Mexico Press.
Dutton, Bertha P.
 1963 *Navaho Weaving Today*. 3d ed. Santa Fe: Museum of New Mexico Press. (Revised edition, 1975.)
Kent, Kate Peck
 1961 *The Story of Navaho Weaving*. Phoenix, AZ: Heard Museum Publication.
Maxwell, Gilbert S.
 1963 *Navajo Rugs: Past, Present and Future*. Palm Desert, CA: Desert-Southwest Publications.
Mera, H. P.
 1947 *Navajo Textile Arts*. Santa Fe: Laboratory of Anthropology, Inc. (Peregrine Smith, Inc. edition, 1975.)
Reichard, Gladys A.
 1936 *The Navajo Shepherd and Weaver*. New York: J. J. Augustin.
Rodee, Marian E.
 1977 *Southwestern Weaving*. Albuquerque: University of New Mexico Press.
Tanner, Clara Lee
 1968 *Southwest Indian Craft Arts*. Tucson: University of Arizona Press.
Wheat, Joe Ben
 1976 "Weaving." In *Indian Arts and Crafts*, edited by Clara Lee Tanner. Phoenix: Arizona Highways Publications.

CONTRIBUTORS

JOE BEN WHEAT is Professor of Natural History at the University of Colorado and Curator of Anthropology at the University of Colorado Museum in Boulder. He is a noted American archaeologist and paleoanthropologist who has excavated extensively in the American Southwest as well as in the Sudan. Joe Ben Wheat is world renowned as an expert on Navajo textiles.

ERIC MITCHELL is Head Photographer for the Philadelphia Museum of Art, whose publications often feature his work. He does freelance photography, and his pictures of architectural work have appeared in several publications.

NOËL BENNETT is Director of Shared Horizons, a nonprofit educational corporation in Corrales, New Mexico, designed to perpetuate the Navajo/ Southwestern textile art tradition. She lived on the Navajo Reservation for eight years; the knowledge and information she gathered there have been published in four books on Navajo weaving techniques and philosophy.